CONTENTS

...ON

...his book to those who are craving to connect with their
...and creativity and have leaned towards starting their
...rney. Welcome!

...ed in 2024

...s Limited
...North Farm Road,
...Vells, Kent TN2 3DR

...ht © Denise Scicluna 2024

...s by Stacy Grant

...y and design copyright
...ress Ltd. 2024

...-80092-176-4
...: 978-1-80093-161-9

...rs
...e difficulty in obtaining any of the materials and equipment mentioned
...k, then please visit the Search Press website for details of suppliers:
...chpress.com

...rked Hub
...r ideas and inspiration, and to join our free online community,
...v.bookmarkedhub.com

...he author
...nore about Denise, and discover more of her work:
...r website: www.denisesciclunaart.com
...stagram: @denisescicluna_art
...cebook: denisesciclunaart

Born in Malta and now based in London, Denise Scicluna is an art psychotherapist, painter and author who enjoys nature, creativity and pebble painting. This is her third book for Search Press, following the success of previous titles *Pebble Pets* and *Rock Art!*. You can find more of her work:

› on her website: www.denisesciclunaart.com

› on Instagram: @denisescicluna_art

› on Facebook: denisesciclunaart

Other books in this series:

The original best-selling Twenty to Make *series has sold over 2 million copies worldwide! In a handy hardback pocket-size format that makes them perfect little gifts, each title in the* All-New Twenty to Make *series contains 20 brand-new projects.*

9781782219675

9781782219811

9781800920989

9781800922044

9781800920873

9781800921399

9781800921009

9781800921603

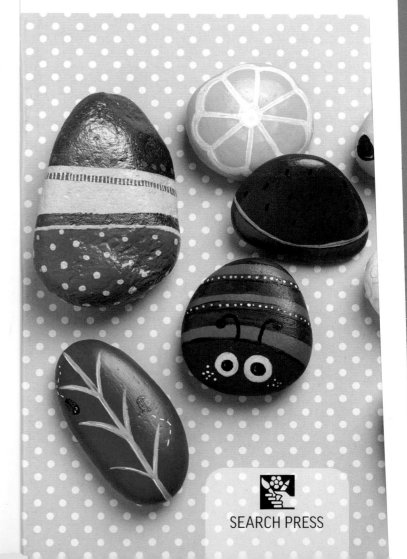

DEDICA

*I dedicate
imaginatie
rock art jc*

First publi

Search Pre
Wellwood
Tunbridge

Text copyr

Photograp

Photograp
© Search

ISBN: 978
ebook ISB

Publish
The Publi
arising fr

Readers a
use, or fc
permissic
permitte

Suppli
If you ha
in this b
www.se

Bookn
For furt
visit ww

About
Find ou
› on h
› on
› on

ALL-NEW
20
TO MAKE
ROC
Denise Sciclu

SEARCH PRESS

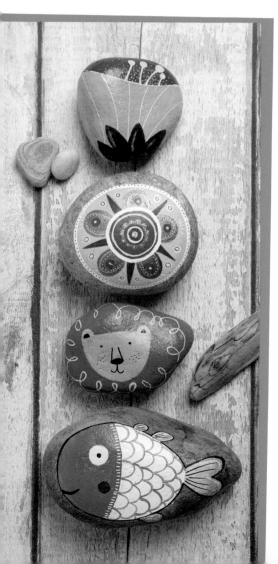

INTRODUCTION

I am Denise Scicluna and I love painting on rocks! I am a qualified and registered art psychotherapist, abstract painter and author based in London. I was born on the sunny Maltese islands, so nature has always been a huge source of inspiration for me: beaches, sunshine, vibrant colours, sunsets. From an early age I loved picking up shells and pebbles from beaches, and little did I know that this would become such a big part of my adult life.

I wanted to write this book for everyone who is curious about rock art. I want to show that rock art is for everyone – children and adults alike – it's simple and fun, and you don't need expensive or fancy materials. Most importantly, I want to show how inspiring nature and natural forms can be. After all, a small pebble with a unique shape can capture your attention, inspire what you paint on it, leading you to designs you hadn't previously considered!

Painted rocks can be used for garden and house décor, creating games, designing jewellery and educational purposes. It is incredible how just a few rocks can lead us into a world of creativity, imagination and play. Choose from the 20 different designs in this book to get you started; then I'd encourage you to create your own. The steps in this book are here to guide you and support the start of your pebble art journey. Remember that we are not after precision and perfection – your pebble can look any way you want to.

I hope that this little book gets your creative juices flowing and that you allow yourself to have fun, play and get messy too!

**I am very excited for you, so let's begin your journey...
Denise**

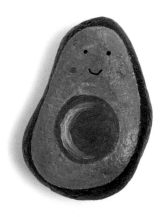

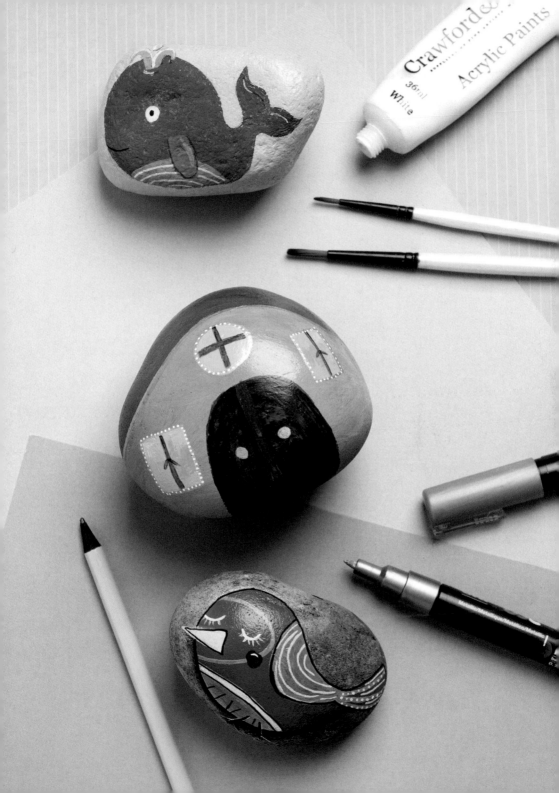

ROCK HUNTING

Is it a pebble or a rock? Where do I find my pebbles? What am I really painting on? How do I know what to paint? If you are asking yourself these questions, these pages are for you.

To start your rock art journey, you will need to get hold of some pebbles. So, to start, it is helpful to know more about the properties of rocks and what to look out for.

PEBBLE OR ROCK?

As a general rule, geologists class all stones and pebbles as rocks, but not all rocks are considered stones or pebbles. A pebble is a small rock that has had its edges smoothed by water erosion.

What makes pebbles so naturally beautiful is their various textures, shapes and colours. You will notice that some of them have streaks of quartz and other sedimentary rock running through them. There are various minerals in pebbles and rocks that make them all distinct from each other. Some of them are quite textured due to prolonged contact with seawater, while others have a smooth surface.

FIND OR BUY?

There are two main ways to source pebbles.

FIND

Go for a pebble hunt in search of your perfect pebble. This option is definitely the most exciting. How amazing is it to create rock art projects from stones that you've found outside your house, on a nature walk or on the beach?

Make it an outing and an adventure: take your family or friends with you and explore your natural surroundings. Pick the stones that catch your attention, and keep an eye out for different shapes, forms, textures and colours.

BUY

If you are not up for hunting, then there is another (easier!) option: all types of pebbles and rocks are available to buy from craft stores, garden centres and online.

When purchasing your pebbles online, make sure you check the description, images and dimensions. Make sure that you pick smooth pebbles and try to avoid overly textured ones. No one pebble will be the same as another, so you'll get to pick which pebbles you want to paint from your delivered bag.

If you buy pebbles in bulk (which is often the most cost-effective option), you can select a few pebbles that you want to paint and leave the rest of the pebbles for another project or another time.

TYPES OF ROCK

There are primarily three types of rocks. Here are some interesting facts about each of them.

SEDIMENTARY

One way to tell if a rock sample is sedimentary is to see if it is made up of grains. These rocks often start as sediments carried in rivers and deposited in oceans and lakes. When they are buried, the sediments lose water and become cemented to form rock. They are often deposited in layers, and frequently contain fossils. Common sedimentary rocks include sandstone, limestone and shale.

IGNEOUS

Igneous rocks are formed through the cooling and solidification of magma or lava. Examples of igneous rocks are basalt, granite and pumice.

METAMORPHIC

These form when rocks are subjected to high heat, high pressure, hot mineral-rich fluids or, more commonly, some combination of these factors. They were once igneous or sedimentary rocks, but have been changed. They are crystalline and often have a 'squashed' (foliated or banded) texture. Examples of this type of rock are marble, slate, gneiss and schist.

THE PERFECT ROCK

The texture and shape are the two most important features to keep in mind when you are rock hunting or shopping. You will be painting or drawing over your rock, so finding one with a smooth surface is key. A rough texture or bumps will make it difficult to create fine lines, small details and sharp outlines.

You also want to look out for the shape: does it match with your idea of what you want to paint on it? How can you translate your design onto the surface of your rock?

BE INSPIRED

As you look through your pebbles you will notice that some stand out more to you than others. The form and shape of a pebble can inspire what you paint on it. For example, a round pebble that is able to stand upright can be used to paint a house or cottage (see opposite). As you get an idea of what you want to paint, you might find it helpful to sketch your design on paper before you commit to your paints. Remember that the sketch does not need to complicated – a few simple lines using pen or pencil are enough. Check out these examples for some inspiration.

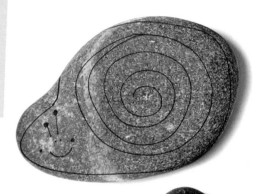

SNAIL

This pebble is perfect for painting a snail. The large round part fits perfectly as a snail shell. You can decorate the shell any way you want or simply draw a spiral right in the centre of the shell.

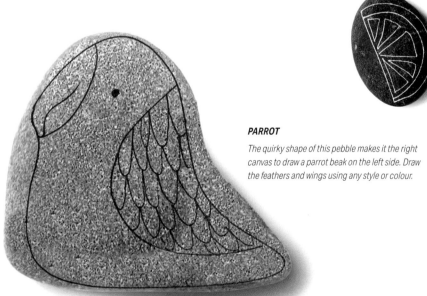

PARROT

The quirky shape of this pebble makes it the right canvas to draw a parrot beak on the left side. Draw the feathers and wings using any style or colour.

MONSTER

Paint a googly-eyed monster on your pebble. Use big eyes and a large mouth and colour him in using any colours that you want.

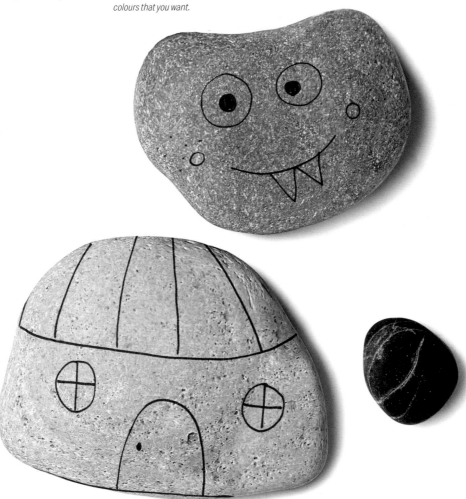

HOUSE

If you find a smooth, standing pebble, then why not paint a cottage or house? If you find more than one, you can make a whole village!

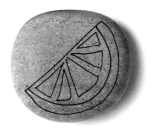

TOOLS AND MATERIALS

PAINTBRUSHES

Use a selection of different brush sizes. It is important to have a small, fine brush to add delicate details or outlines, while a large brush is perfect for covering bigger surfaces, such as painting the base colour of your rock.

PENS

Pens are used to add small details and outlines, especially if you do not have a tiny paintbrush. Posca pens are brilliant and my personal favourite, but other permanent markers can also be used. It is helpful to have a black pen, at least, as part of your tool set.

CHALK OR PENCILS

Sketching your design onto your pebble before painting helps you organize your design and check your proportions. You do not need to add a lot of detail: simply sketch the main outline and main sections on the pebble using white chalk or a pencil. White chalk is perfect if you are using a dark pebble.

VARNISH

Choose between spray or liquid varnish once your design is dry.

ACRYLIC PAINT

Acrylics are the best paint for pebbles (avoid using watercolours or oils). You can purchase a set of different colours or buy single tubes if you have a particular colour scheme in mind.

PAINTING ESSENTIALS

You will need a container to mix your paints in, a cup of water, a cloth to wipe your brushes on and lastly a tablecloth or newspaper to protect your painting space.

ADDITIONAL ITEMS

For a cute, cartoon-like effect, you might want to glue googly eyes to your pebble monsters or animals. You may also want to use a hairdryer to speed up the drying process.

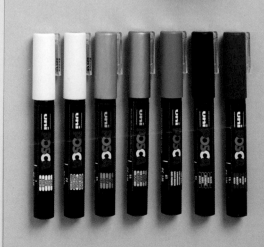

PREPARATION

SKETCHING YOUR IDEAS

Sketch your designs on paper before starting to paint your pebble.
Prepare the colours that you will be using. There is no need for a detailed
sketch – simply add the main outline together with some small details
and then start painting!

SKETCHING ON LIGHT PEBBLES

Sketching your design on the pebble gives an idea
of how you can use the surface of your pebble. It
also helps you get an idea of the proportion and
shape of your design. If you are using a light pebble,
use a pencil to sketch your design onto your rock.

SKETCHING ON DARK PEBBLES

If your chosen pebble is dark, it will be hard to mark
your sketch with a pencil. Instead, use a white
pencil or chalk to sketch the design.

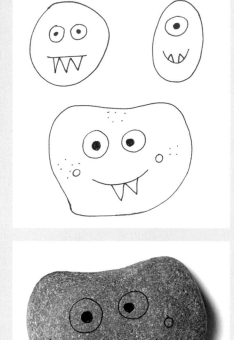

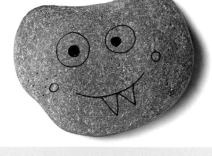

FINISHING YOUR DESIGN

VARNISHING

Not only does varnish create a layer of shine over your pebble, it also helps protect the layers of paint and makes the colours pop. You can use spray varnish or liquid varnish. Choose from matt, glossy, semi-glossy or satin effect.

If you are using liquid varnish, use a large brush to cover the surface of your painted rock in as few strokes as possible. It is important that if you used any pens that they are either Posca pens or permanent ones, otherwise your varnish might lift and smudge your pen lines!

Make sure you apply spray varnish outdoors, keeping the spray can a few centimetres/inches away from your pebble surface so that it covers evenly.

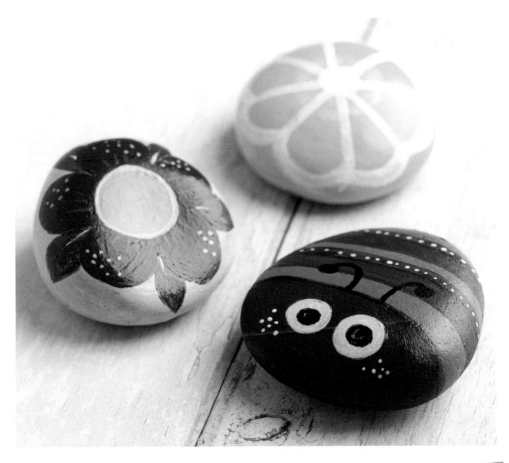

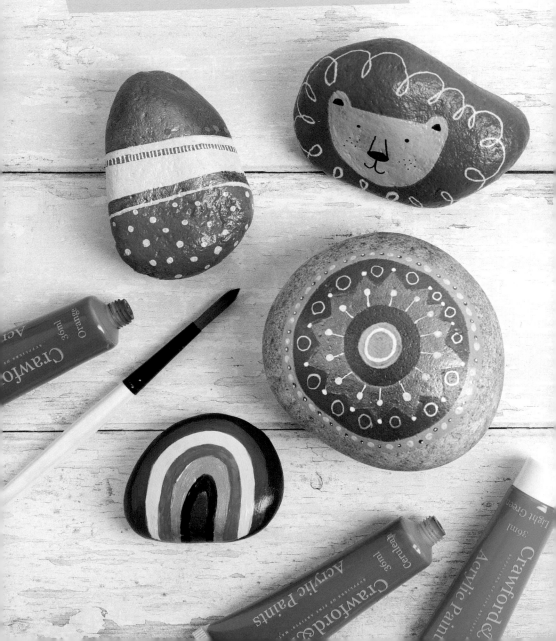

THE PROJECTS

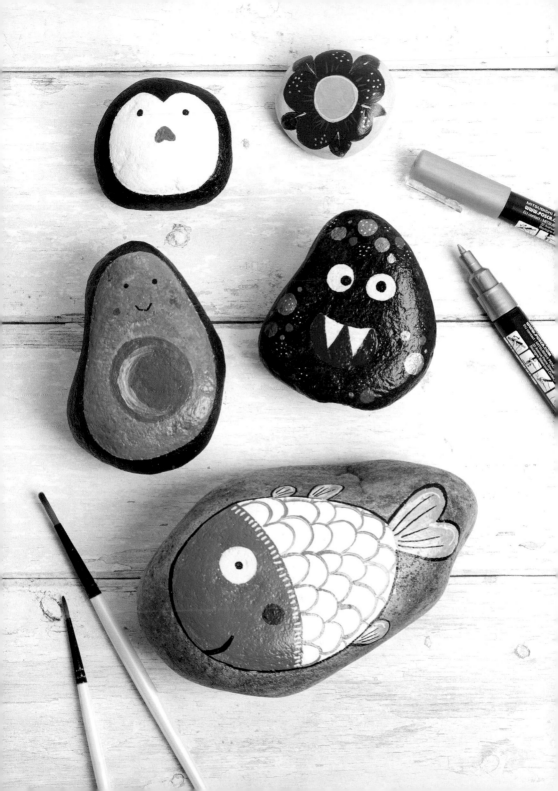

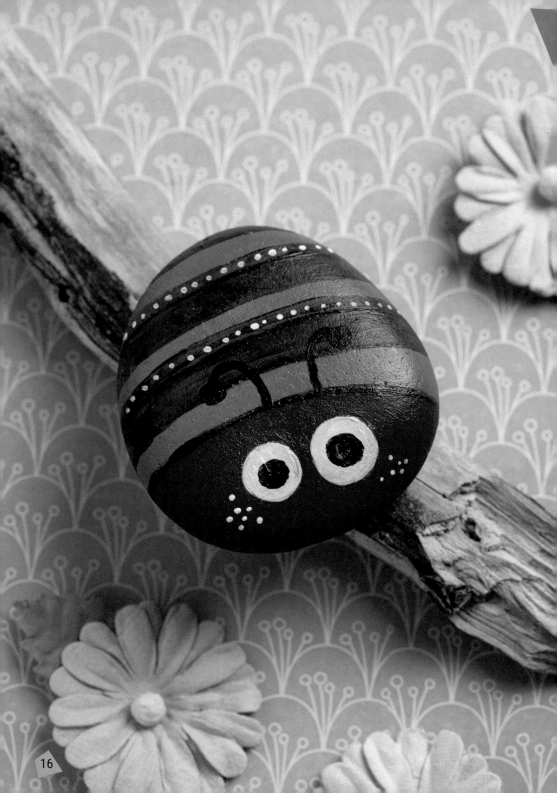

CATERPILLAR

YOU WILL NEED

- Red, yellow, and light and dark green paint
- Black and white paint or pens
- Chalk or pencil
- Varnish
- Brushes

INSTRUCTIONS

1 Choose a flat, smooth, circular pebble and wash it.

2 Outline the body, head and eyes of the caterpillar using pencil or chalk.

3 Paint the head red and the eyes yellow.

4 Using your green paints, paint the stripes on the body.

5 Use black paint or a pen to add the pupils and a pair of antennae.

6 Add small dots on the stripes and cheeks using white paint or a pen.

7 Varnish when dry.

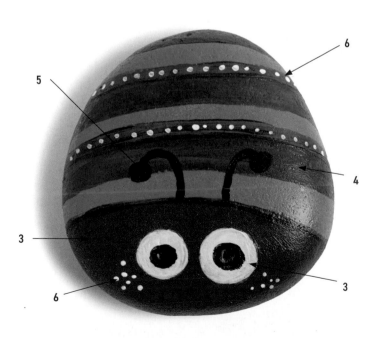

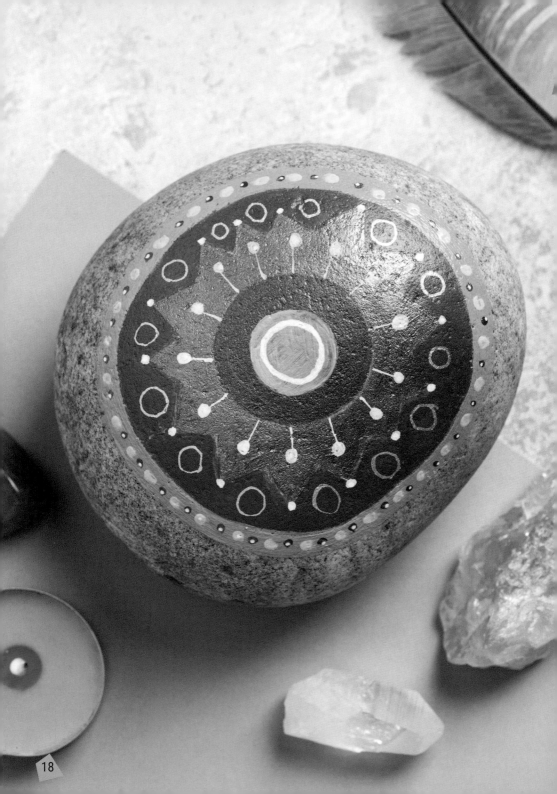

MANDALA

YOU WILL NEED

- Copper, silver and beige paint
- White paint or pen
- Chalk or pencil
- Varnish
- Brushes

INSTRUCTIONS

1 Choose a large, round, smooth pebble and wash it.

2 Using chalk or pencil, start making rounded shapes from the centre outwards. Experiment with different patterns.

3 Once you have your mandala design sketched on your pebble, start by painting the centre with copper and beige paint.

4 Paint the outer layers using silver and copper paint.

5 Once dry, use your white and beige paint or pens to add dots, circles and other patterns around your circular layers.

6 Varnish once dry.

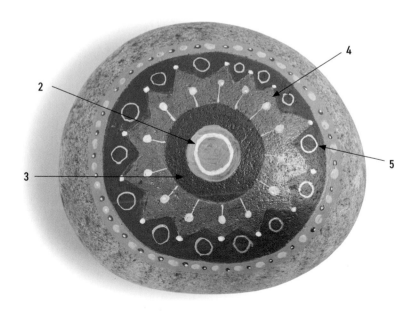

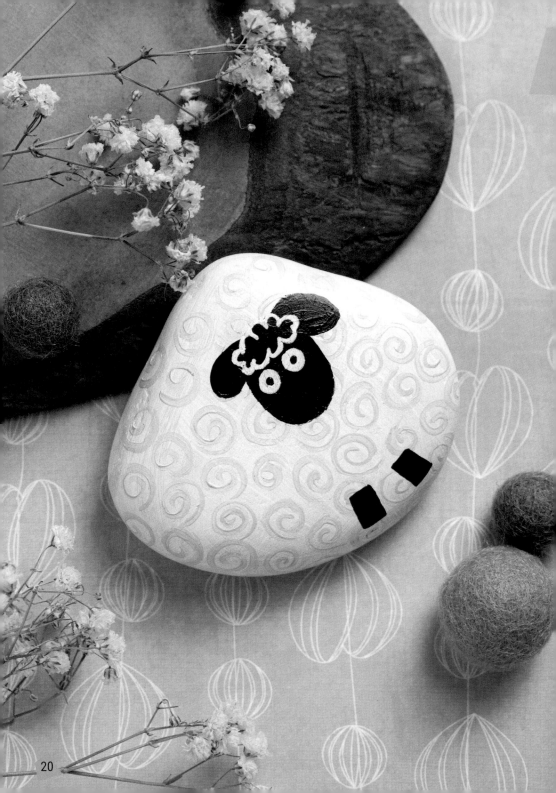

SHEEP

YOU WILL NEED

- Beige or light brown paint
- Black and white paint or pens
- Pencil
- Varnish
- Brushes

INSTRUCTIONS

1 Choose a flat, smooth, circular pebble and wash it.

2 Paint the pebble using white paint. Add a second layer of white paint if needed.

3 Use a pencil to outline the shape of the head. Outline the feet by drawing two small rectangles at the bottom of the pebble.

4 Use black paint or pen to fill in the head and feet.

5 Use white paint or pen to add eyes and fur in the shape of a cloud at the top of the head.

6 Use beige or light brown paint to paint spirals all around the body of the sheep.

7 Varnish once dry.

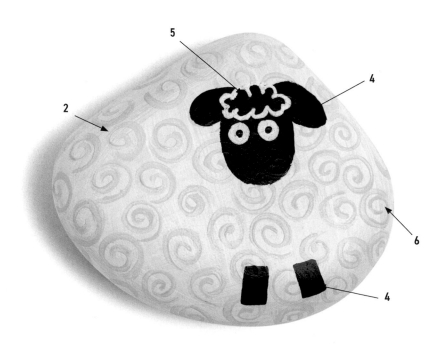

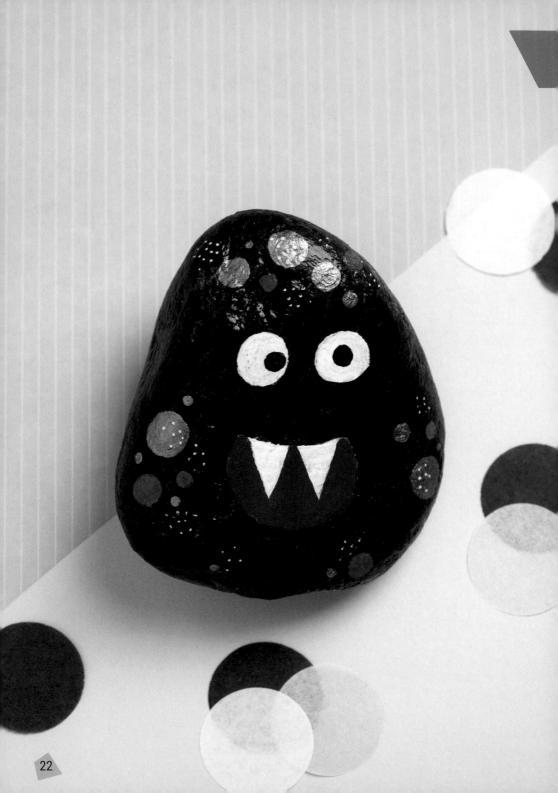

GOOGLY-EYED MONSTER

YOU WILL NEED

- Dark blue, mid-blue and silver paint
- Red, black and white paint or pens
- Chalk/pencil
- Varnish
- Brushes

INSTRUCTIONS

1 Find an odd shaped pebble and wash it.

2 Use pencil/chalk to outline two eyes and a mouth with two sharp teeth.

3 Paint your monster using dark blue paint.

4 Use white paint or pen to fill in the eyes and teeth. Use red paint or pen for the mouth.

5 Use black to complete the eyes.

6 Add more details by painting circles all over the monster's body.

7 Varnish when dry.

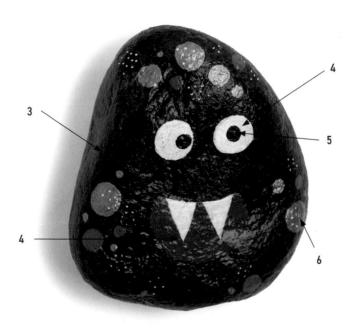

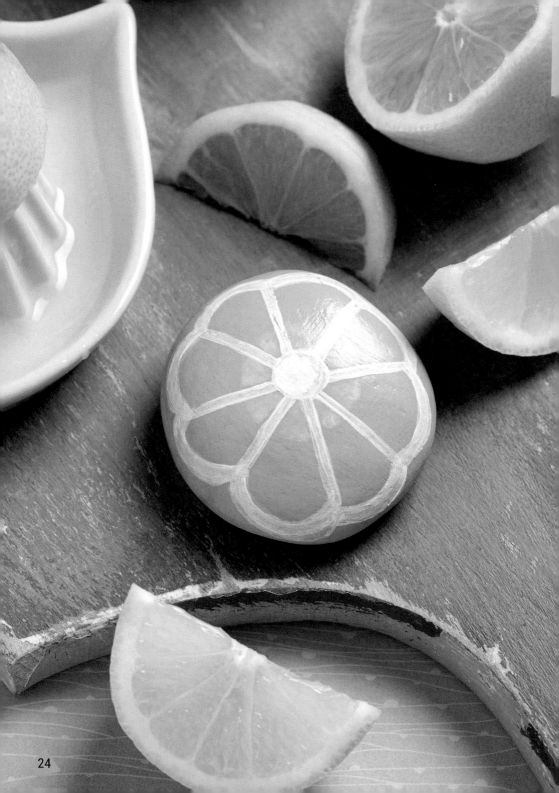

LEMON

YOU WILL NEED

- Yellow paint
- White paint or pens
- Chalk or pencil
- Varnish
- Brushes

INSTRUCTIONS

1 Choose a round, smooth pebble and wash it.

2 Paint your pebble using yellow paint. Give it a second coat of paint for a bolder look.

3 Once dry, use your pencil or chalk to mark the inner lemon markings. Start with a small circle in the middle.

4 Add lines and join them together by adding curved lines in between each line. This will create a big, round circle.

5 Once your outline is complete, go over the lines with white paint or pen.

6 Varnish once dry.

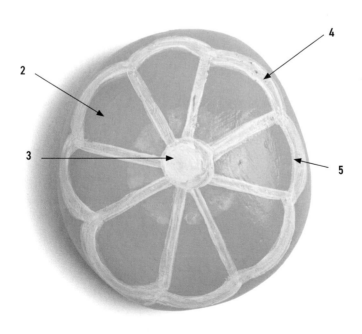

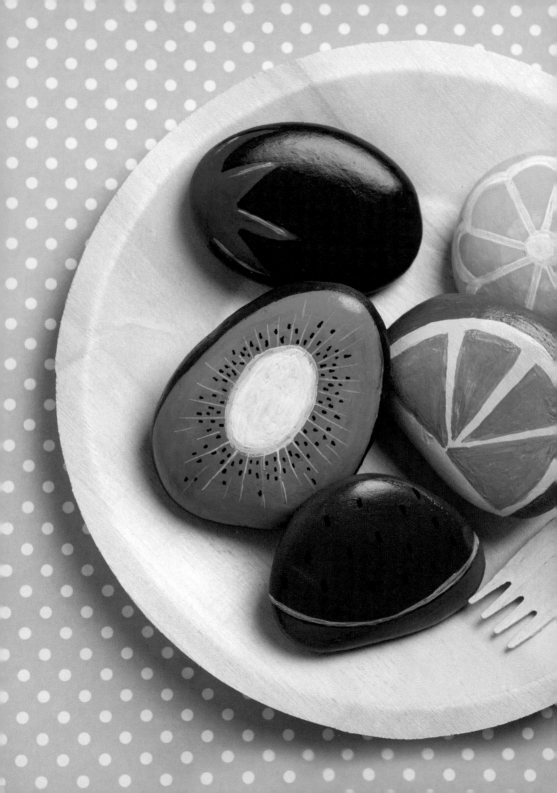

FRUIT VARIATIONS

Turn your pebbles into your favourite colourful fruits!

For this project you need small, smooth, flat pebbles. Let the shapes of the pebble inspire which fruits you paint.

If you know what fruits you want to paint, you can set yourself on a fun pebble hunt and search for the perfect pebble that matches the shape of your chosen fruit!

Try to paint a slice of lemon or mandarin on a rounded pebble. If you have a triangular, flat pebble, why not paint a slice of juicy watermelon? For oval-shaped pebbles, you could try out a strawberry or a kiwi!

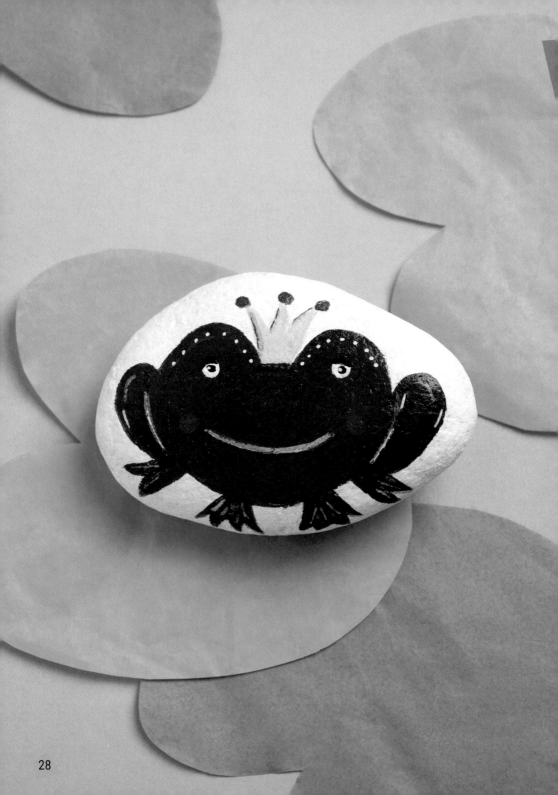

FROG

YOU WILL NEED

- White, light and dark green, black, yellow and red paint
- Black paint or pen
- Chalk or pencil
- Varnish
- Brushes

INSTRUCTIONS

1 Choose a smooth, oval-shaped pebble and wash it.

2 Paint the pebble white.

3 Use your pencil to outline the shape of the frog starting from the face, then legs and arms. Add a crown between the eyes.

4 Paint the frog using dark green paint. Add the mouth and highlights using a lighter shade of green.

5 Using black and white paint or pens, add the eyes, and the line of dots above the eyes.

6 Use yellow and red paint to fill in the crown. Add two cheeks on the face.

7 Varnish when dry.

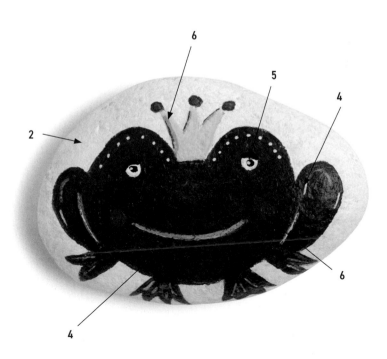

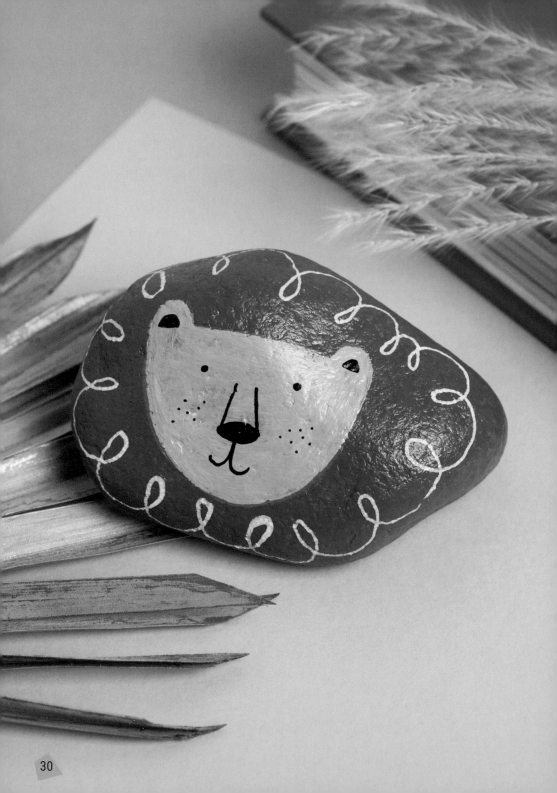

LION

YOU WILL NEED

- Orange and yellow paint
- Black paint or pen
- Yellow pen
- Chalk or pencil
- Varnish
- Brushes

INSTRUCTIONS

1 Choose a large, smooth pebble and wash it.

2 Draw the face of the lion using pencil or chalk.

3 Paint the outside of the pebble, the mane, using orange paint.

4 Paint the face using yellow paint.

5 When dry, use black paint or pen to add a pair of eyes, ears, the nose and mouth. Add a few dots on the cheek.

6 Use yellow paint or pen to add a curly pattern around the lion's mane.

7 Varnish when dry.

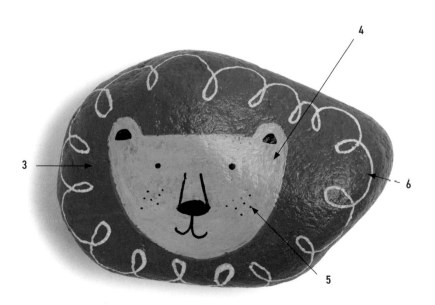

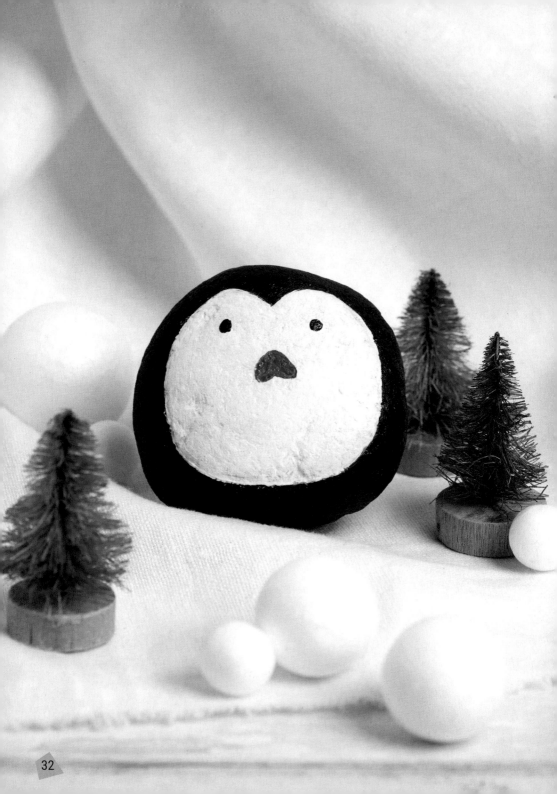

PENGUIN

YOU WILL NEED

- Orange and white paint
- Black paint or pen
- Chalk or pencil
- Varnish
- Brushes

INSTRUCTIONS

1 Choose a round, smooth, standing pebble and wash it.

2 Use your pencil or chalk to outline the white, inner part of the penguin.

3 Paint the outer part in black paint and the inner part in white.

4 Once dry, add a pair of eyes with black paint/pen and a beak with orange paint.

5 Varnish once dry.

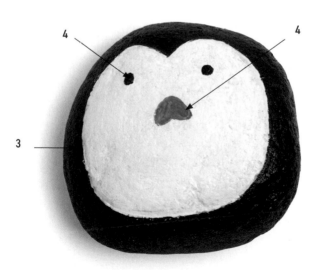

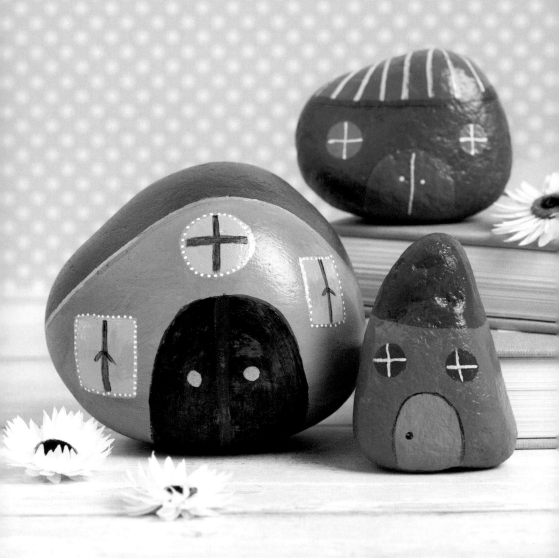

COTTAGE

YOU WILL NEED

- Light pink, dark pink, brown, gold light blue and green paint
- White paint or pen
- Chalk or pencil
- Varnish
- Brushes

Alternative colourway (for the other houses):
Orange, light turquoise and dark turquoise

INSTRUCTIONS

1 Choose a standing, roundish pebble and wash it.

2 Use a pencil or chalk to outline the roof, door and three windows.

3 Paint the roof of the house using dark pink paint, the windows in light blue, the door in green and the rest of the house in light pink.

4 Use brown paint to add the divider on the front door and use green to add the details to the windows.

5 Use gold paint to outline the windows, the roof and to add two door handles.

6 Add white dots around the window frames using paint or a pen.

7 Varnish once dry.

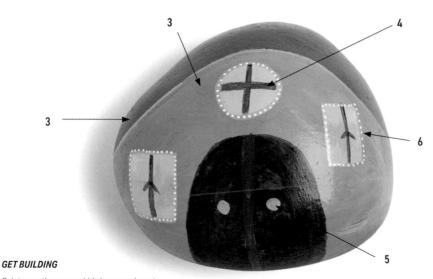

3 **4** **3** **6** **5**

GET BUILDING

Paint more than one pebble house and create your own village! Paint both sides to make them three-dimensional and perfect for playtime.

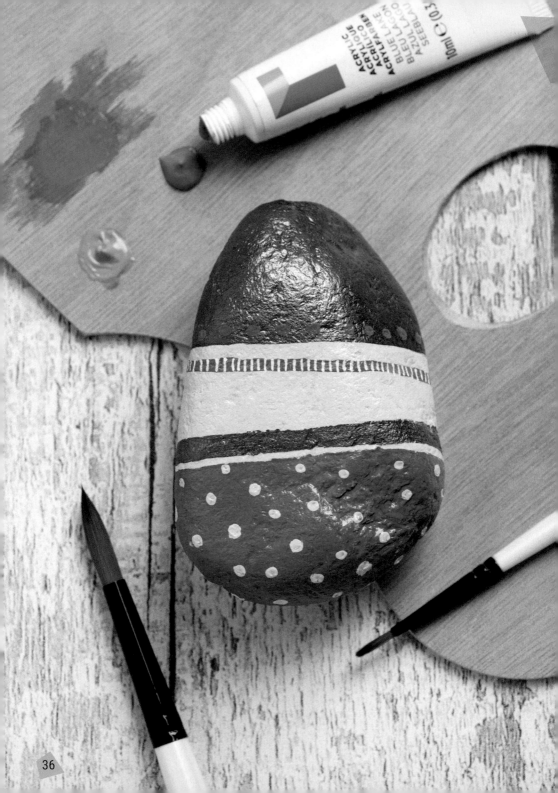

ABSTRACT PATTERN

YOU WILL NEED

- Bronze, blue and white or beige paint
- Chalk or pencil
- Varnish
- Brushes

INSTRUCTIONS

1 Pick a large pebble and wash it.

2 Using your pencil, divide your pebble into different sections using horizontal lines.

3 Paint the top section bronze.

4 Fill in the other sections using blue and beige or white paint.

5 Once all sections are painted, add lines and dots in various sections of your pebble using more bronze, beige and blue.

6 Varnish once dry.

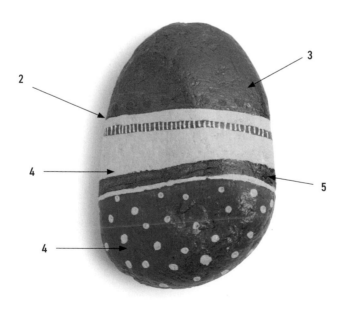

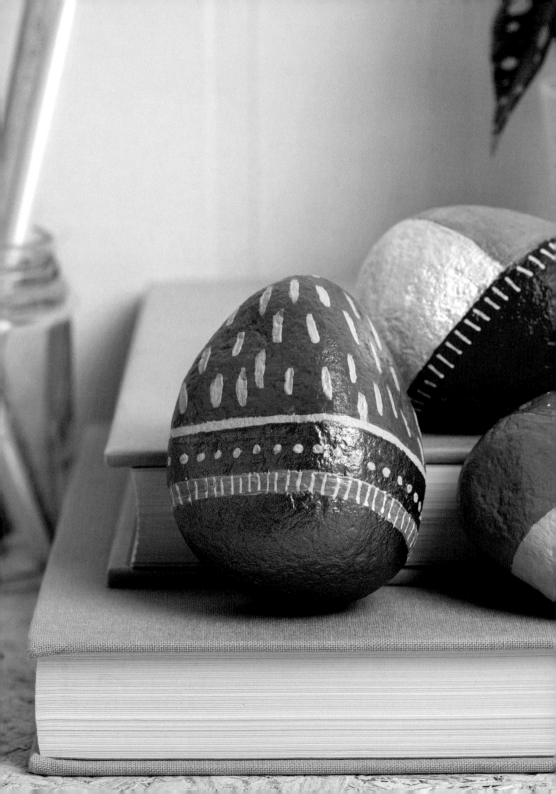

ABSTRACT PATTERN VARIATIONS

Let your creativity flow with these abstract art pebbles. Select any pebble of any size and transform it into a work of art!

For each pebble, select a combination of three to four colours. Divide your pebble into different sections and paint each part a different colour. Use pens or paint to add small details such as patterns, dots and lines.

Varnish when dry and enjoy your collection of abstract art on pebbles!

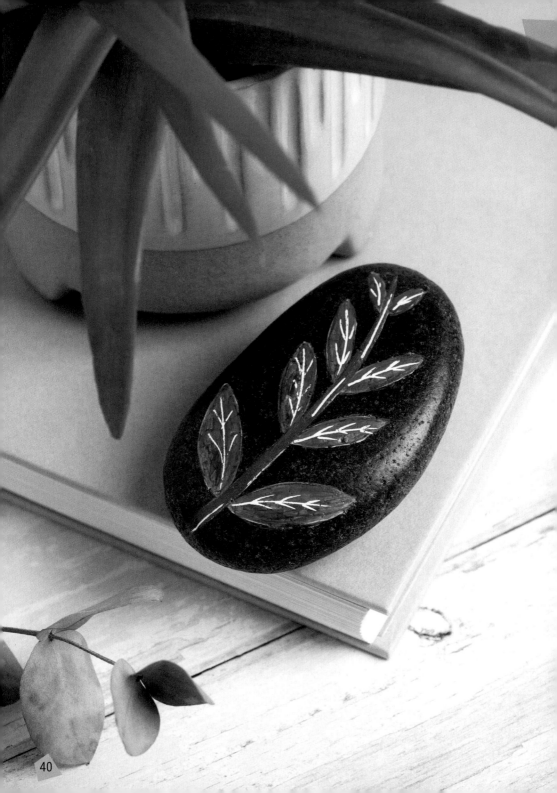

PLANT

YOU WILL NEED

- Green and brown paint
- White paint or pen
- Chalk or pencil
- Varnish
- Brushes

INSTRUCTIONS

1 Choose a smooth, dark pebble and wash it.

2 Use chalk or pencil to outline the shape of the plant starting with the stem and then adding leaves on each side.

3 Use brown paint to colour in the stem.

4 Paint all the leaves using green paint.

5 Using white paint or pen, mark the pattern inside each leaf.

6 Varnish when dry.

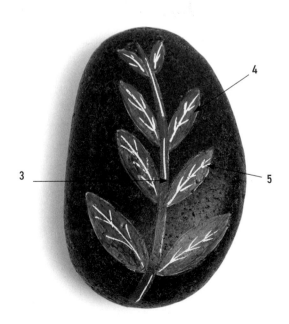

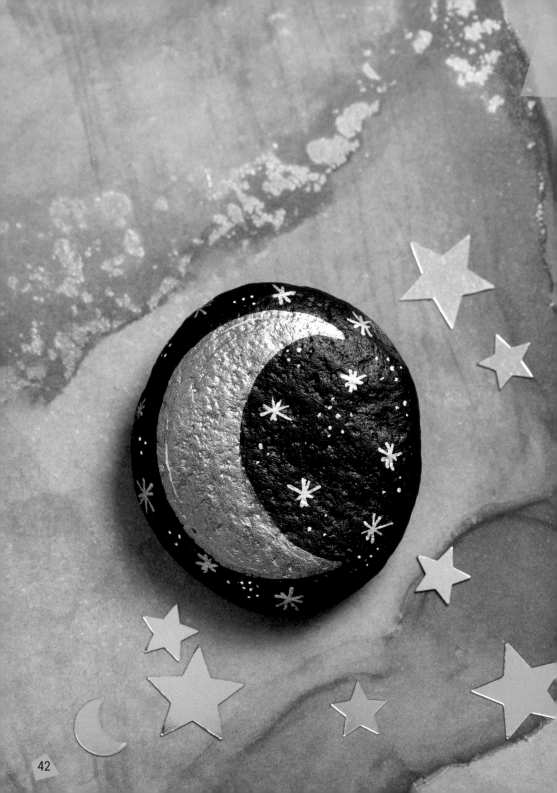

MOON

YOU WILL NEED

- Black and silver paint
- Gold and white paint or pens
- Chalk or pencil
- Varnish
- Brushes

INSTRUCTIONS

1 Choose a round pebble and wash it.

2 Paint the pebble using black paint.

3 Using chalk or pencil, mark the shape of a moon on the dry black surface.

4 Paint the moon using silver paint.

5 Add stars around the moon using gold and white paint or pens.

6 Varnish when dry.

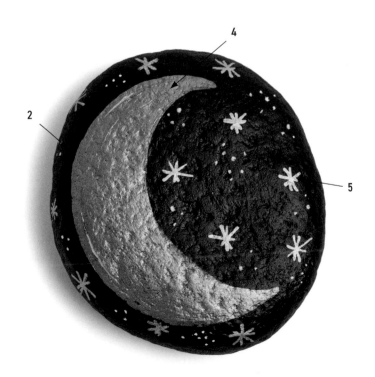

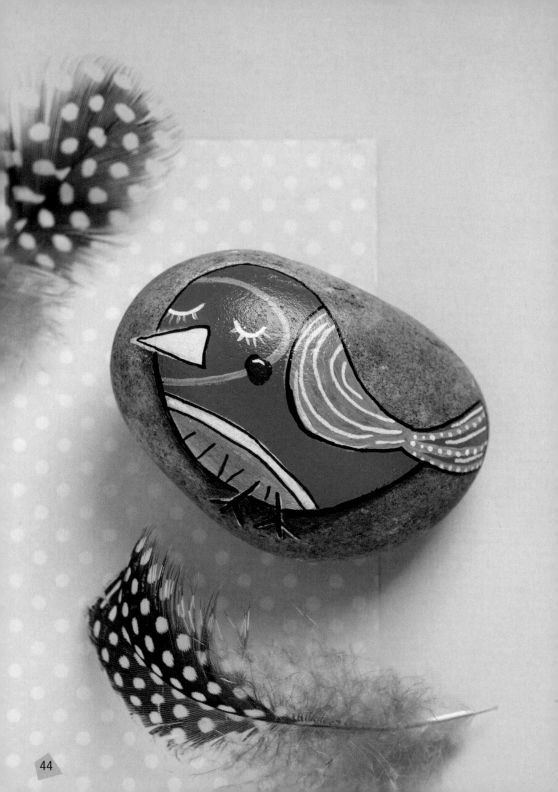

BIRD

YOU WILL NEED

- Blue, yellow and red paint
- Black and white paint or pens
- Chalk or pencil
- Varnish
- Brushes

INSTRUCTIONS

1 Find a round, smooth pebble and wash it.

2 Use your chalk or pencil to outline the shape of the bird.

3 Paint the bird in blue and, once dry, outline the small details with chalk or pencil.

4 Use a light shade of blue to paint the wing and tail. Use yellow over the belly.

5 Add the beak, eyes and a red cheek.

6 Add the legs and then outline your bird using black paint or pens to make it stand out.

7 Varnish once dry.

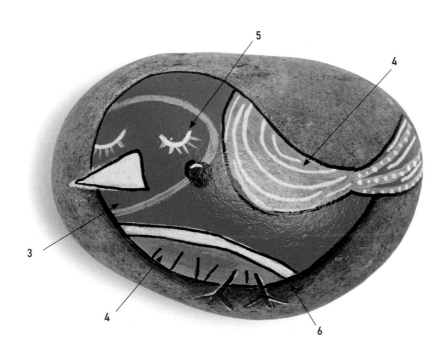

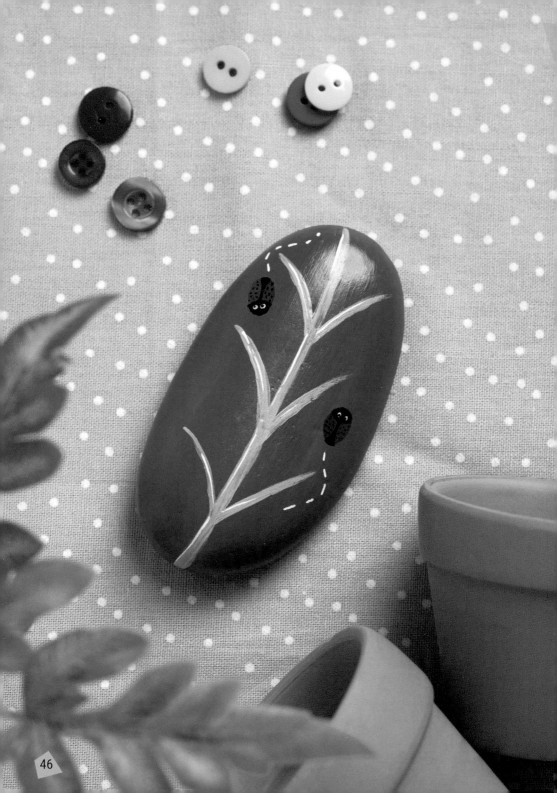

LEAF

YOU WILL NEED

- Mid- and light green paint
- White, red and black paint or pens
- Chalk or pencil
- Varnish
- Brushes

INSTRUCTIONS

1 Choose an oval-shaped pebble and wash it.

2 Paint it using mid-green paint. Add a second layer of paint to make the colour bolder.

3 Once dry, use chalk to outline the veins of the leaf. Paint the veins with light green paint.

4 Use white, red and black paint or pens to create two ladybirds on the leaf.

5 Varnish once dry.

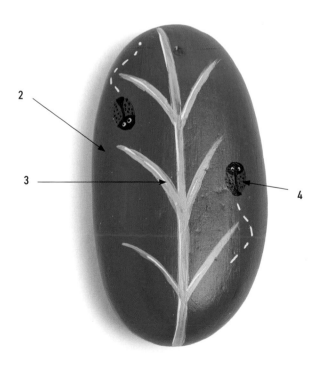

2

3

4

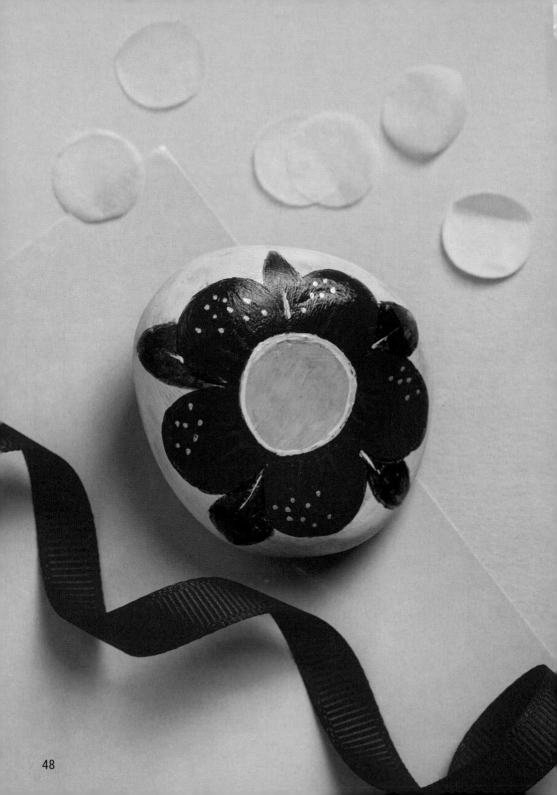

RED FLOWER

YOU WILL NEED

- Red, light red, yellow, pale yellow, green and white paint
- Gold paint or pen
- Chalk or pencil
- Varnish
- Brushes

INSTRUCTIONS

1 Choose a round, smooth pebble and wash it.

2 Paint your pebble white.

3 Once dry, use your pencil or chalk to create a flower with large petals, and with leaves in between some of the petals.

4 Paint the centre of the flower with yellow paint, and use red paint for the petals.

5 Paint the leaves using green paint.

6 Add little details such as dots, outlines and lines on the petals and leaves using paint or pens.

7 Varnish once dry.

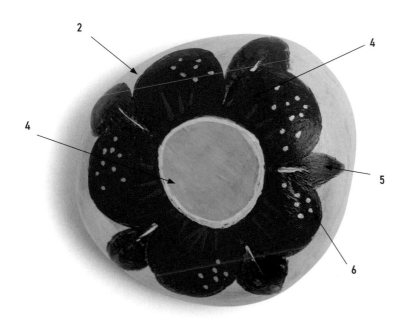

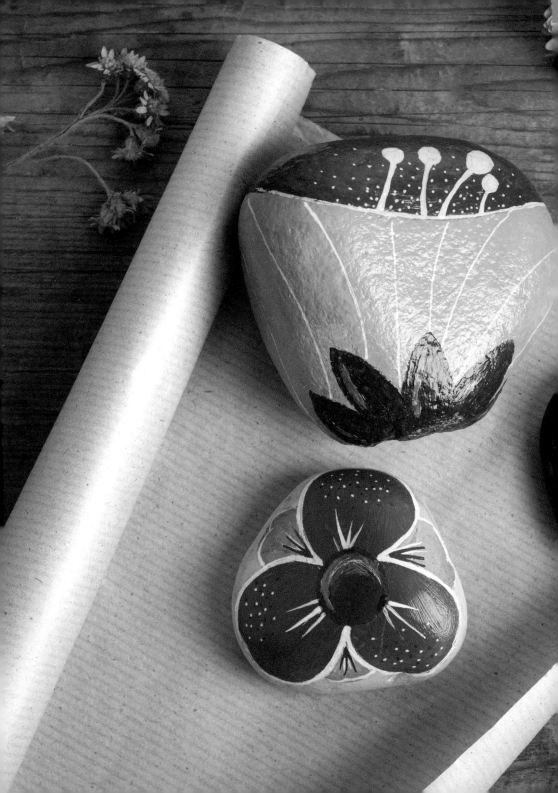

FLOWER VARIATIONS

Whether you choose your favourite flowers, or make up your own, painting flowers on pebbles is a guaranteed fun, creative and colourful project!

Sketch your chosen flower with pencil and chalk. Then use paint and pens to start bringing your flower to life.

Paint open flowers, or blossoming flowers. Paint flowers with large petals or flowers with leaves on the side.

Let yourself get creative with the small details that you can add on the petals: use dots and lines inside the flower and on the petals to make your flower stand out!

Have fun creating a garden of beautiful and colourful pebble flowers!

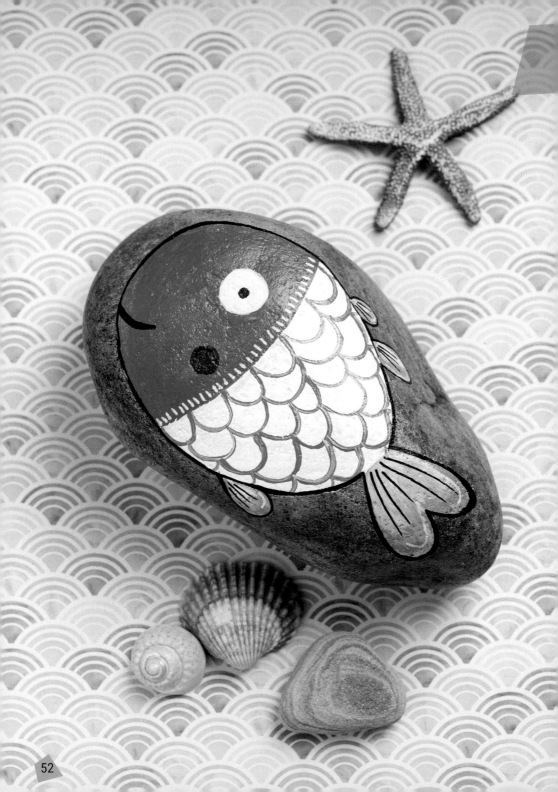

FISH

YOU WILL NEED

- White, blue, yellow, black and red paint
- Black pens
- Chalk or pencil
- Varnish
- Brushes

INSTRUCTIONS

1 Choose a large, smooth, oval-shaped pebble and wash it.

2 Outline an oval shape and a tail on the right side of the oval using chalk or pencil. Add fins on the top and bottom.

3 Use white and blue paint to create the scale pattern and face of the fish.

4 Using yellow paint, colour in the tail and fins.

5 When dry, add little details such as an eye, mouth, cheek, and add black lines on the tail and fins.

6 Once the paint is all dry, add a black outline and then varnish your pebble.

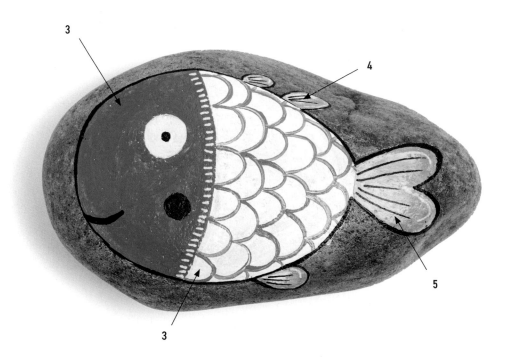

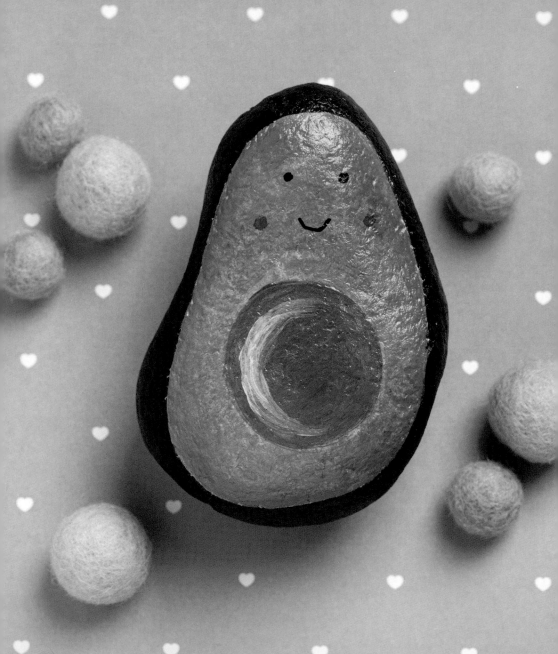

AVOCADO

YOU WILL NEED

- White, orange, dark brown, dark and light olive green paint
- Black paint or pen
- Chalk or pencil
- Varnish
- Brushes

INSTRUCTIONS

1 Choose an avocado-shaped pebble that gets wider at the bottom, and wash it.

2 Use chalk or pencil to outline the avocado and the circular seed.

3 Paint the inner part using light olive green paint and then paint the outer part using dark brown paint.

4 Use a dark shade of olive green paint to colour the seed. Add a highlight effect using white paint to give it depth.

5 Use black paint or pen to add a pair of eyes and a smile. Add spots on the cheek for a cheeky look.

6 Varnish once dry.

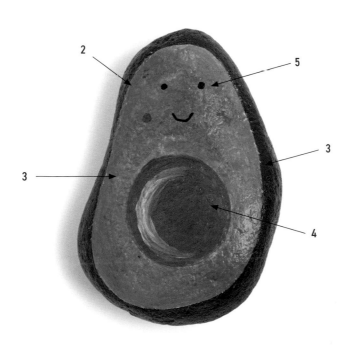

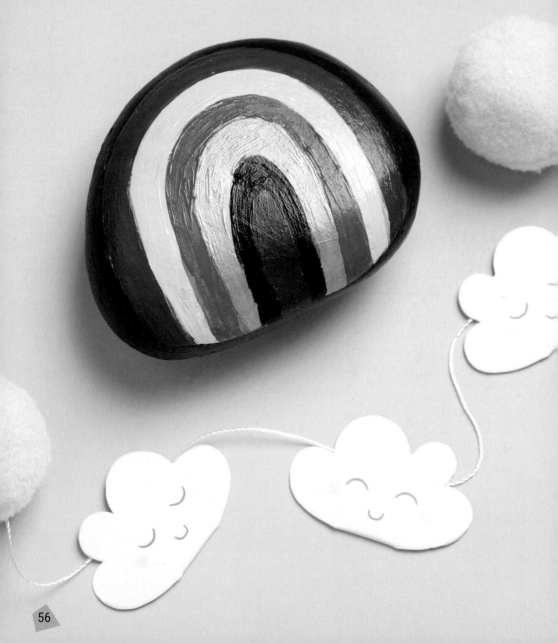

RAINBOW

YOU WILL NEED

- Paint in all colours of the rainbow
- Chalk or pencil
- Varnish
- Brushes

INSTRUCTIONS

1 Choose a semi-circular pebble and wash it.

2 Using chalk or pencil, add six semi-circular lines to create your rainbow shape.

3 Colour each of the seven sections using the correct order of the rainbow.

4 Varnish once dry.

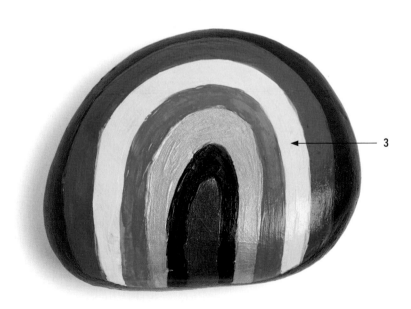

3

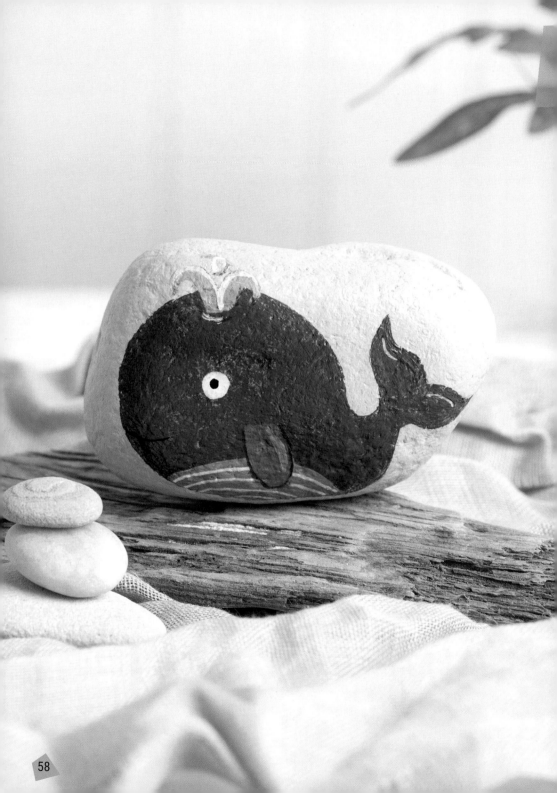

WHALE

YOU WILL NEED

- Shades of blue paint
- White, beige and black paint or pens
- Chalk or pencil
- Varnish
- Brushes

INSTRUCTIONS

1 Find a smooth, standing pebble and wash it.

2 Paint your pebble using a light paint such as white or beige.

3 Use chalk or pencil to outline the shape of the whale, then paint it blue.

4 Using a lighter shade of blue, cover the belly part and add a jet of water on the top of the head.

5 Add extra effects using white paint over the belly and water, and create highlights around the whale.

6 Use white and black paint or pens to add the eye and mouth. Varnish when dry.

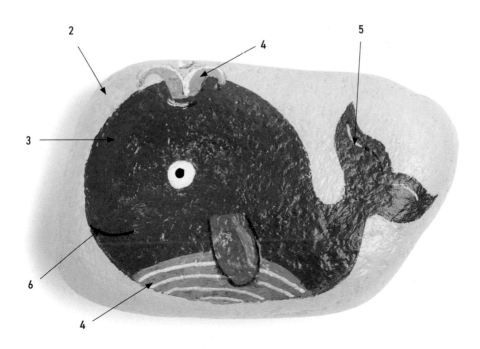

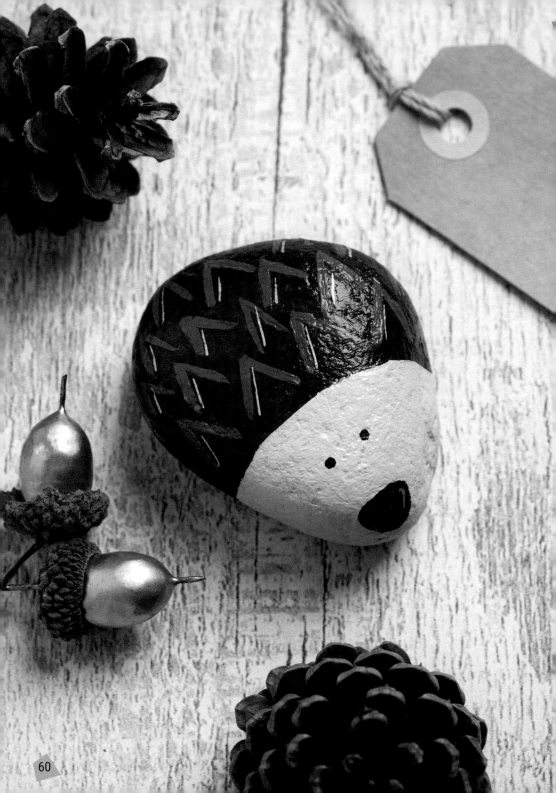

HEDGEHOG

YOU WILL NEED

- Light, medium and dark brown paint
- Gold pen or paint
- Black paint
- Chalk or pencil
- Varnish
- Brushes

INSTRUCTIONS

1 Choose a triangular-shaped pebble and wash it.

2 Using chalk or pencil, mark the face, taking up one-third of the pebble. Paint it using light brown paint.

3 Paint the rest of the pebble using dark brown paint.

4 Once dry, add pointed patterns all over the dark brown that look like spikes using a medium brown paint. Use golden paint or pen to add an effect on the spikes.

5 Add a pair of black eyes on the face and a nose using brown or black paint.

6 Varnish once dry.

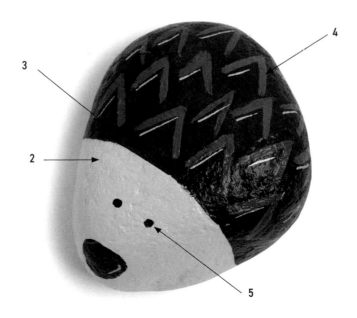

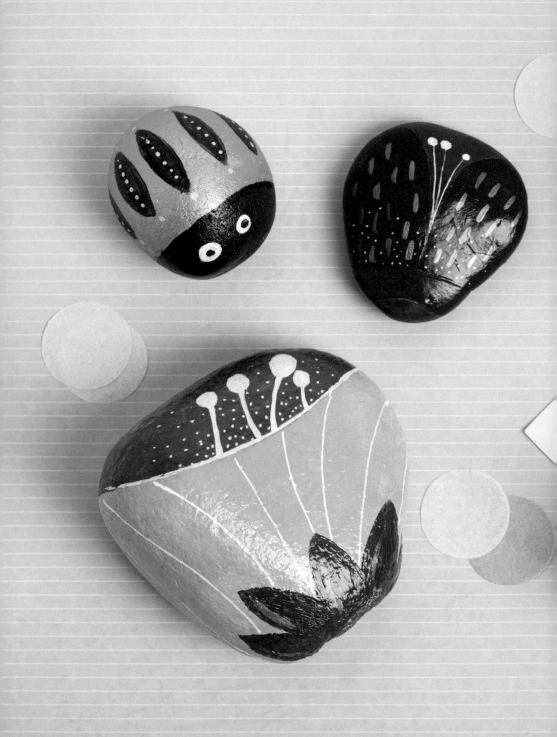

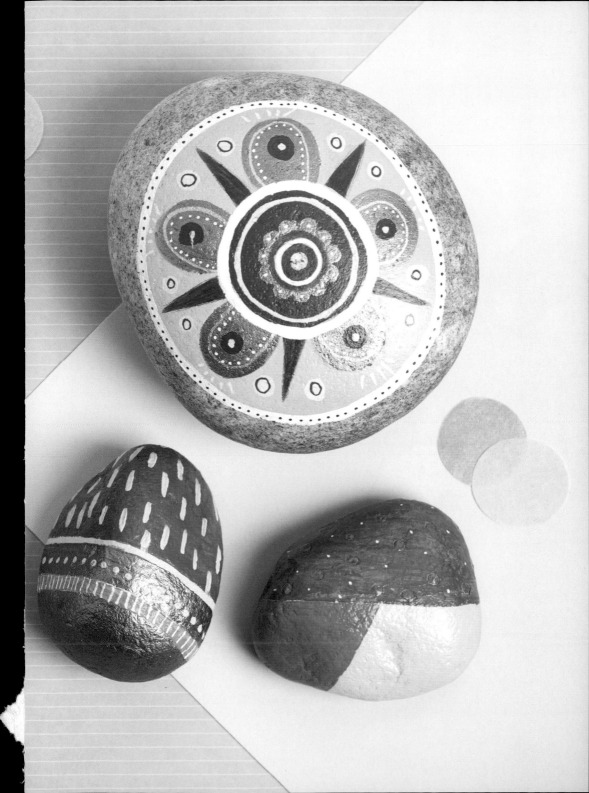